The Pastel Counterproofs

14

The Pastel

Counterproofs

FOREWORD BY

Warren Adelson

PREFACE BY

Marc Rosen and Susan Pinsky

ESSAY BY

Jay E. Cantor

ADELSON GALLERIES NEW YORK

Renoir: The Pastel Counterproofs

Presented by

Marc Rosen Fine Art, Ltd.

220 EAST 73RD STREET
NEW YORK, NY 10021
TELEPHONE 212 535-5283
WWW.MARCROSENFINEART.COM

November 1 to December 23, 2005

Adelson Galleries

THE MARK HOTEL
25 EAST 77TH STREET
NEW YORK, NY 10021
TELEPHONE 212 439-6800
WWW.ADELSONGALLERIES.COM

This book was published on the occasion of the exhibition

ISBN 0-9741621-2-4

Library of Congress Control Number: 2005934220

Printed in the United States of America
10 9 8 7 6 5 4 3 2 1

Front cover:
Jeunes Femmes au Moulin de la Galette
[cat. 2, p. 21]

Design: Marcus Ratliff Inc.
Composition: Amy Pyle
Photography: Gilles de Fayet
Color imaging: Center Page Inc.
Lithography: Meridian Printing

Contents

Foreword

ADELSON GALLERIES is delighted to exhibit this remarkable collection of pastel counterproofs by Pierre-Auguste Renoir. While our gallery's major focus is American art, we have proudly hosted a number of exhibitions devoted to European art and especially to works on paper by Impressionist and modern masters. We believe that the understanding of American art is enhanced by the juxtaposition of American works and their European counterparts. These exhibitions, buttressed by a series of old master drawings exhibitions presented by Flavia Ormond, and modern European masters by Lefevre Fine Art Ltd. and Thomas Gibson Fine Art Ltd., have provided historical insights as well as a kaleidoscope of artistic achievement.

Art in a Mirror: The Counterproofs of Mary Cassatt was our first exhibition of a rare and special medium. In it, we presented never-before-seen works by this legendary American artist. We now present a parallel exhibition of counter-proofs also from the collection of Ambroise Vollard that provide important new insights into the work of Cassatt's contemporary and famed French master, Pierre-Auguste Renoir. These exhibitions have been organized in association with our distinguished colleagues and friends, Marc Rosen and Susan Pinsky.

We are especially pleased to present *Renoir: The Pastel Counterproofs*, a collection of hitherto unknown works by Renoir, for exhibition and sale for the first time.

WARREN ADELSON

Preface

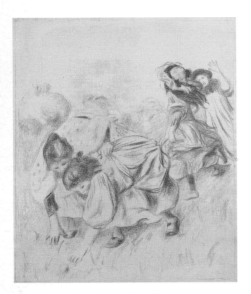

Fig. 1. *Enfants jouant à la balle*
Crayon drawing

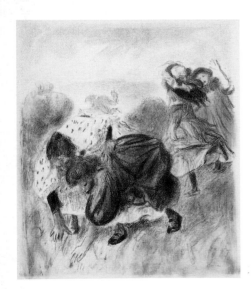

Fig. 2. *Enfants jouant à la balle*, ca. 1900
Color lithograph

T HE THIRTY-FOUR works included in this catalogue represent the second part of an extraordinary horde of pastel counterproofs by Mary Cassatt and Pierre-Auguste Renoir. They were put away in portfolios nearly a century ago by the eminent dealer, Ambroise Vollard, and remained in complete obscurity, as a time capsule, until their recent rediscovery.

As with the Cassatt counterproofs, which we presented last year, it appears that Vollard provided both the means and the impetus for the creation of these works. Auguste Clot, a resourceful printer and master lithographer (who also helped Degas to produce over 100 counterproofs), printed the editions for Vollard's famous sets and individual lithographs by many artists of the day, including Pierre Bonnard, Maurice Denis, Renoir and Edouard Vuillard. He had also refined the method for transferring a pastel image to a fresh sheet of paper by using a lithographic press to apply the necessary even pressure. He protected the surface of the pastel from undue abrasion and enhanced the luminous transparency of the counterproof by transferring the image to a smooth and soft, tissue-thin Japan paper, backed for support with a sturdier sheet.

At the end of the 19th century, when the demand for Renoir's work was steadily growing, Vollard commissioned Renoir to create lithographs, and employed Clot to transfer the artist's finished drawings to lithographic stones. One such drawing in this collection, *Enfants jouant à la balle* [Fig. 1], was transferred to stone and printed as an edition in black only, and then also in colors [Fig. 2]. A pastel counterproof in this group [17] is closely related. Once transferred to stone, the drawing would have appeared in the same orientation as the counterproof, facilitating the development of the color version of the lithograph.

Another of the counterproofs [24] is closely related to the development of the color lithograph, *L'Enfant au biscuit*. Still another [18] recalls the imagery

of Renoir's famous color lithograph, *Le Chapeau épinglé* [Fig. 3, the drawing stone printed in blue-green; and Fig. 4, the edition printed in eight colors]. One, *Les Baigneuses au crabe* [32], is remarkable in that it documents the source pastel at a stage of development before final adjustments to the contours of the figures, shedding light on the deliberate care and visual discipline with which Renoir built compositions that appear entirely spontaneous. Finally, several have added importance as transfers of pastels whose whereabouts are now unknown.

The dating of Renoir's pastel images is often difficult, because favorite themes recur and his style remains relatively consistent over many years. The pastels for the counterproofs in this collection were documented by Vollard on large glass slides, but these were in black and white, and so, for many of the pastels, the counterproofs provide our first knowledge of their colors. Renoir scholar Pascal Perrin believes that the revelation of the colors will help in more precise dating of the pastels, and it is our hope as well that this catalogue and exhibition will add substantially to the understanding of Renoir's work.

We would like to thank M. Guy Wildenstein for his time spent discussing the Renoir counterproofs and for making available the research resources of the Wildenstein Institute. M. Pascal Perrin, of the Renoir catalogue raisonné project at the Wildenstein Institute, has been extraordinarily generous in spending many hours reviewing the files of the Institute and in discussing questions of dating and identification of the subjects. (We wish to emphasize that the Wildenstein Institute is not presently preparing a catalogue raisonné of Renoir's pastels, and that any information provided in this catalogue is therefore subject to revision upon further review.)

Warren Adelson, President of Adelson Galleries, has provided enthusiastic support and encouragement from the inception of this endeavor. We are indebted to him and to the staff of Adelson Galleries, who have, as always, done their utmost to further the realization of this project. We are grateful to Jay Cantor of the Mary Cassatt Catalogue Raisonné Committee for his lively essay discussing the pastel counterproofs in the context of the relationship between Renoir and Vollard. Special thanks are due to Andrea Maltese for shepherding the catalogue through production, and to Marcus Ratliff and Amy Pyle of Marcus Ratliff Inc. for catalogue design.

MARC ROSEN AND SUSAN PINSKY

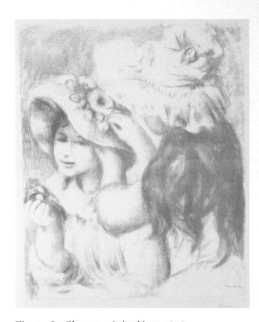

Fig. 3. *Le Chapeau épinglé*, ca. 1898
Lithograph printed in two colors

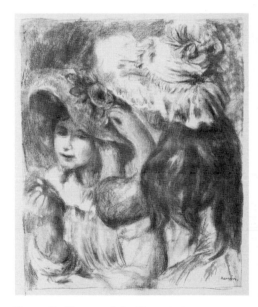

Fig. 4. *Le Chapeau épinglé*, ca. 1898
Lithograph printed in eight colors

Renoir and Vollard: A Comfortable Intimacy

Iᴛ ɪs ɴᴏᴛ sᴜʀᴘʀɪsɪɴɢ, in a way, that Pierre-Auguste Renoir would have embraced the experimentation and technical innovations fostered by Ambroise Vollard and his frequent collaborator, the printer Auguste Clot. Renoir was a dedicated worker who continually sought perfection in his art and willingly explored new mediums. Even crippling illness did not deter this master of the Impressionist generation from working tirelessly at his art. Renoir, like many of his circle, had exhibited regularly with the long-established Galeries Durand-Ruel, but once Vollard emerged on the scene around 1893, he vied for the painter's loyalties, ultimately acquiring work for both his gallery and his private collection. It may well have been Renoir's very willingness to explore new mediums and Vollard's prescient and dogged commitment to the graphic arts that enhanced the relationship of these two aesthetic pioneers.

Vollard had joined a small group of dealers exhibiting contemporary art in Paris at the turn of the 20th century. He was energetic and resourceful and propelled himself into the artistic landscape of the French capital (which was, by most accounts, the worldwide artistic capital) with a vitality matched only by the heady spirit of the artists themselves. He was at once patron, collaborator and historian of much that was emergent in the artistic ferment of the pre-World War I years. While enthusiastically embracing the avant-garde community, Vollard was equally committed to the artistic forbears of the modern revolution.[1]

Vollard reserved special reverence for Paul Cézanne, Renoir, Edgar Degas and Mary Cassatt. Whether these enthusiasms were spurred by a strong sense of commercial opportunity or by pure artistic instinct, the results had an important impact on the careers of these artists. Having mounted the first solo exhibition for Cézanne in 1895, within a couple of years of opening his gallery, he also became a print publisher at the apex of the widespread enthusiasm for

artist printmaking.[2] Through these activities, Vollard also forged alliances with a young generation including Édouard Vuillard, Pierre Bonnard and Odilon Redon. Vollard cajoled the older artists, including Degas, Cassatt, and Renoir and, to a modest extent, Cézanne, to either produce new images for prints or to collaborate on the appropriation of existing pastels, drawings and watercolors for lithographic editions or in the making of counterproofs from both older works and more recent productions. The story of Vollard's publishing and dealing relationship with Cassatt is told in our two earlier exhibition catalogues: *Mary Cassatt, Prints and Drawings from the Artist's Studio* (2000) and *Art in a Mirror: The Counterproofs of Mary Cassatt* (2004). The present exhibition adds new insights into the better documented interchange between Vollard and Renoir.

While Vollard's relationship with Cassatt can only be traced through a handful of letters and documents, by the works he sold and the collection he assembled, as well as by the counterproofs that were produced between about 1905 and 1915, his interactions with Renoir are much better known. Their amiable relationship, beginning with an introduction through Berthe Morisot, led to a deep commitment to the artist's work on Vollard's part. Although Renoir's principal dealer was Galeries Durand-Ruel, Vollard appears to have played an active role in promoting the artist. He planned and published a catalogue raisonné, a two-volume work which appeared in 1918, the year before Renoir's death, and followed it with an artistic biography, *La Vie et l'oeuvre de Pierre-Auguste Renoir,* published in 1919. Renoir had actually seen the manuscript before his death and recorded his approbation in a letter to Vollard, noting, "Fortunately, you haven't made me talk too much rubbish."[3]

In a series of chapters in which Vollard claims to provide transcriptions of conversations between dealer and artist, he supplies a narrative of Renoir's influences, admirations, career moves and artistic philosophies as well as offering insights into the artist's working methods. The very fact of such extended conversations implies a comfortable intimacy between the two and offers hints as to Renoir's willingness to engage in experimental activities such as the production of counterproofs. One comment in particular is revealing. In the retelling of a luncheon with Rodin who visited Renoir at his country home, the painter is quoted as saying: "Vollard showed me some extraordinary reproductions of your water-colours." In reply, Rodin credits the printer: "I did them with the help of Clot. When he is gone, lithography will be a lost art."[4]

It was, in fact, Clot who probably did the pastel counterproofs, which required putting a properly dampened piece of paper on top of a pastel or drawing and carefully running them through a press with just the right pressure to transfer a reverse impression of the work without damaging it. In this and in his printmaking techniques, Clot was an acknowledged master. He specialized also in creating reproductive prints that conveyed the special character of an artist's original and thus the remark that his lithograph for Rodin actually emulated the qualities of a watercolor.[5]

Clot had developed such sophisticated techniques in response to a flagging market for traditional prints after the market was glutted with colorful lithographs and posters at the end of the 19th century. It is probably fair to say that the enthusiasm for much more subtly colored prints by artists like Vuillard and Bonnard was in part a response to some of the more strident color print work done at the close of the century. And it was similarly the soft modulated tonalities of Renoir's works that would translate so brilliantly from pastel into both lithographs and counterproofs. Renoir noted his admiration for the pastels of Degas, especially as they related to his own exploration of a muted palette in the mid-1880s : "Well, look at his pastels. Just to think that with a medium so very disagreeable to handle, he was able to obtain the freshness of a fresco! When he had that extraordinary exhibition of his in 1885 at Durand-Ruel's, I was right in the midst of my experiments with frescoes in oil. I was completely bowled over by that show."[6]

A drypoint by Renoir, entitled *Mère et enfant,* was included in the first of Vollard's two large albums, *L'Album des peintres-graveurs,* of 1896, which was followed the next year by his first lithograph published with Vollard, *Le Chapeau épingle* [see p. 9, Figs. 3 and 4]. (He had actually made two lithographs in 1896 for an unpublished print folio, *L'Album d'estampes originales de la Galerie Vollard,* 1898 -). Seven individual lithographs and etchings, including portraits of *Richard Wagner,* ca. 1900, *Paul Cézanne,* 1902, and *Auguste Rodin,* ca. 1910–1914, preceded Vollard's ultimate print tribute to Renoir's achievement, completed in 1904 but not issued until the year of the painter's death: *Douze Lithographies originales de Pierre-Auguste Renoir* (1919).

Vollard also instigated Renoir's foray into sculpture, resulting in the production of more than a dozen bronzes between 1913 and 1917. As recounted by Una Johnson in her pioneering study *Ambroise Vollard, Editeur: Prints, Books, Bronzes* (The Museum of Modern Art, 1977): "It was Vollard who, on a visit to Cagnes, urged Renoir to work with a young assistant. Renoir was to supply the

drawings and to supervise the work in plaster. First amused by such an idea, Renoir was soon involved in the plan." In a description that parallels the role Clot played in print production from artists' original drawings, watercolors and pastels, Johnson continues: "With some dispatch, he [Vollard] brought the young sculptor Richard Guino to Renoir's studio. Guino had worked with Maillol and was unusually skilled in the various techniques of sculpture. He was also able and amenable to carrying out a style that was not necessarily his own. In the end Vollard's idea prevailed, with Vollard electing to pay Guino's expenses. This unusual arrangement proved to be uniquely successful, and the working relationship between Renoir and Guino was a happy and productive one. In fact, Guino's interpretations of Renoir's drawing, instructions, and wishes were so deft and expert that Renoir's bronzes and terra-cottas have always been accepted as originals."[7]

Renoir's ultimate collaboration with Vollard was the two-volume catalogue, *Renoir's Paintings, Pastels and Drawings,* published in 1918. In it Vollard reproduced 1,741 works by the artist. It is interesting to note that at the time of his death, more than 700 works remained in Renoir's possession, but the more than 1,000 that had already left his hands were an extraordinary testament to the esteem in which this pioneer of Impressionism was held during much of his professional life.[8] In complimenting Vollard on his book, Renoir wrote from Cagnes on 3 March 1918: "My Dear Vollard, I received the reproductions that you made for your work on me and I am pleased to tell you that I find them perfect. I am enchanted. Yours, Renoir."[9]

While this exhibition of unknown Renoir pastel counterproofs will continue to enchant the admirer of Renoir's work, it also adds to the artist's legacy. It provides us with a small-scale survey of his favored subjects and themes. It includes the street scenes and café subjects of Renoir's early career, portraits and scenes of domestic life as well as later and more idyllic images of nudes in a landscape. Evident throughout are the intimate touches and tonal harmonies that give Renoir's work its lasting appeal. Cropped compositions suggestive of the influence of Degas, whose work Renoir admired, are counterpointed by classically composed images. Although a participant in the most advanced tendencies of modern art in Paris, Renoir had a marked traditional streak. He found solace in museums and in the work of old master painters whom he much admired. He was especially enamored of frescoes, whose often bleached and flattened tonalities are recalled in many of the artist's pastels and in their counterproofs. These convey the sense of joy in observation as well as in the

making of the work of art itself. Renoir's art is informed by nature but is also very much a product of the studio. In one of his most telling comments to Vollard, Renoir opined: "It is not enough for a painter to be a clever craftsman; he must love to 'caress' his canvas too. That's what was lacking in Van Gogh. 'What a wonderful painter!' people say. But his canvases do not show the light, tender touch of the brush. And there's his rather exotic side too. . . . But try to tell your critics that art is not only a question of craftsmanship, but also that there must be a certain something that the professors can't give you—finesse, charm, perhaps—that can't be taught."[10] It is, however, wonderfully evident in this remarkable collection.

JAY E. CANTOR

NOTES

1. For more information on Vollard's activities in this period, see Jay E. Cantor, "'Vollard is a genius in his line,'" *Art in a Mirror: The Counterproofs of Mary Cassatt* (New York: Adelson Galleries, 2004), pp. 11–21, and Una E. Johnson, *Ambroise Vollard, Editeur: Prints, Books, Bronzes* (New York: The Museum of Modern Art, 1977).

2. Ambroise Vollard, *Recollections of a Picture Dealer* (New York: Dover Books, 2002), translated by Violet M. MacDonald and first published in English by Little, Brown & Company, Boston, in 1936

3. Ambroise Vollard, *Tableaux, Pastels & Dessins de Pierre-Auguste Renoir* (Paris, 1918), reprinted in a single volume as *Pierre-Auguste Renoir: Paintings, Pastels and Drawings* by Alan Wofsy Fine Arts, San Francisco, in 1989.

Renoir's quote appears in Johnson, *Ambroise Vollard*, p. 30.

4. Ambroise Vollard, *Renoir: An Intimate Record*, translated by Harold L. Van Doren and Randolph T. Weaver (New York: Alfred A. Knopf, 1925), p. 209. Their reciprocal friendship is also reflected in the several portraits Renoir did of Vollard.

5. For a discussion of Clot's career and innovations, see Pat Gilmour, "Cher Monsieur Clot, Auguste Clot and his role as a colour lithographer," in *Lasting Impressions, Lithography as Art* (Canberra: Australian National Gallery, 1988), pp. 129–75.

6. Vollard, *Renoir: An Intimate Record*, p. 86.

7. Johnson, *Ambroise Vollard*, p. 41. These sculptures are now sometimes catalogued as Renoir and Guino.

8. Albert André and Marc Elder, *L'Atelier de Renoir* (Paris, 1931), reprinted as *Renoir's Atelier* by Alan Wofsy Fine Arts, San Francisco, in 1989, illustrates 720 works with catalogue notes by Messrs. Bernheim-Jeune.

9. Vollard, *Tableaux*, p. vi.

10. Vollard, *Renoir: An Intimate Record*, p. 129.

Notes on the use of the Catalogue

THIS CATALOGUE includes a representative selection from the ensemble of nearly 70 counterproofs by Renoir placed in storage by Ambroise Vollard early in the last century.

All of the pastels from which the counterproofs were taken are documented on black-and-white glass slides in the Vollard archives. Many of these are reproduced in Vollard's 1918 catalogue (Ambroise Vollard, *Tableaux Pastels & Dessins de Pierre-Auguste Renoir*, Paris, 1918, two vols.), and are referred to here by his numbers (as "V…"). Several remained unpublished, perhaps intended for a subsequent volume. Were it not for the counterproofs published for the first time in this catalogue, many of these pastels would now be entirely unknown to the public. Furthermore, since Vollard's catalogue illustrations are black and white, it is only now that we can see the colors of so many of these works.

The pastels appear to date from about 1875 to 1900 and, based on our knowledge of Vollard's relationship with Renoir, we believe that the counter-proofs of these pastels may date from about 1895 to 1905.

Titles

Vollard gave titles to only those works included in the first volume of his catalogue and these were only for quick reference. Other authors have used a variety of titles of their own invention. The titles we use in this catalogue are based on the documentation available at this time, as reviewed with Pascal Perrin of the Wildenstein Institute, and are subject to further revision.

Dates

We list provisional dates for the source pastels, based on current scholarship, including information provided by the Wildenstein Institute. In many instances, the dating is still under review, and it is our hope that the revelation of the colors of these works will make that task easier.

Signatures

If a counterproof includes a reverse signature transferred from the source pastel, this is noted in our catalogue entry by the phrase "with counterproof signature." If the work includes a monogram signature, "R" or interlaced "AR," this is indicated as "with counterproof monogram." In a few instances, signatures do not appear on the counterproofs because the pastels were signed after the counterproofs were made.

Paper and dimensions

Most of the counterproofs are on tissue-thin Japan paper, mounted on sturdy wove paper. However, three are on Japan mounted on laid paper, perhaps for aesthetic suitability to the subjects. These are catalogue numbers 6, 12 and 22.

The dimensions given are those of the image or mat opening, height before width, in both inches and centimeters.

Catalogue

1.

Au Moulin de la Galette

ca. 1875–1876

Pastel counterproof
on Japan paper
18⅝ × 24 in. (47.3 × 61 cm)

The pastel is in the National Museum, Belgrade, Serbia
(illustrated in Denis Rouart, *The Unknown Degas and
Renoir in the National Museum of Belgrade*, New York,
McGraw-Hill, 1964, pp. 98–9).

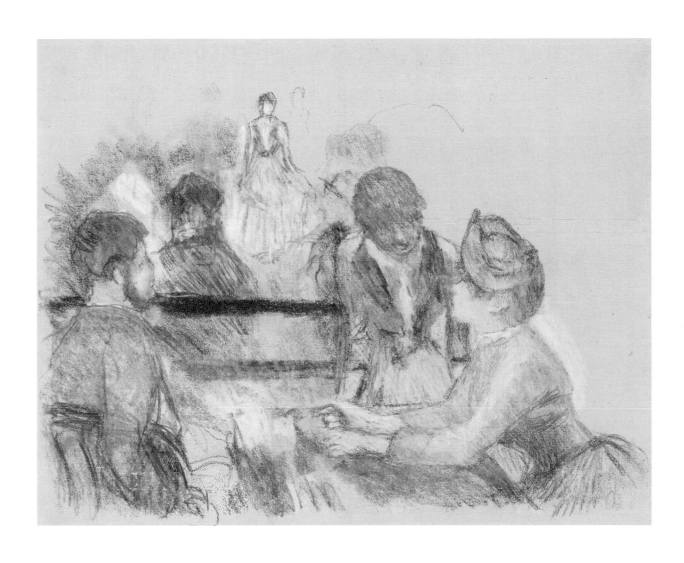

2.

Jeunes Femmes au Moulin de la Galette

ca. 1875–1876

Pastel counterproof of V. 1414
on Japan paper
15¾ × 12⅞ in. (40 × 32.7 cm)

This composition corresponds to the right-hand part of
the counterproof, *Au Moulin de la Galette*, catalogue no. 1.

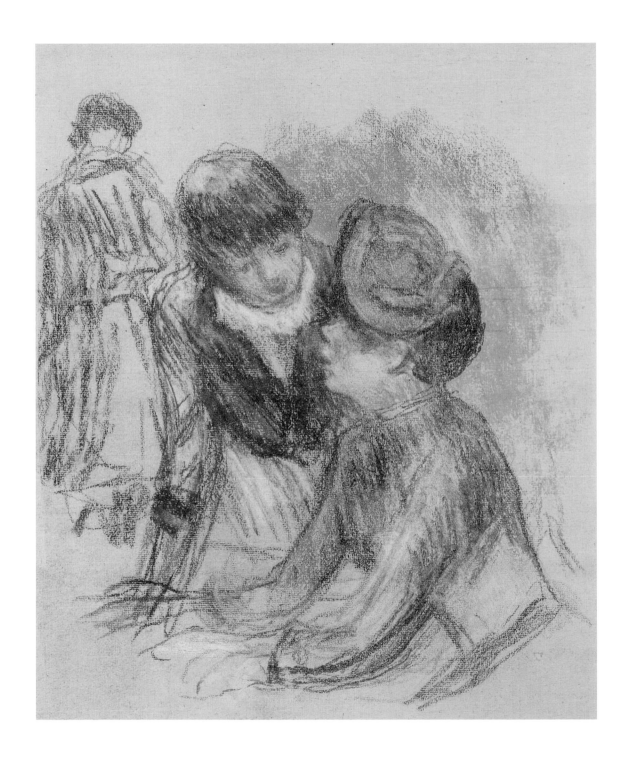

3.

La Conversation au Moulin de la Galette

ca. 1875–1876

Pastel counterproof of V. 760
on Japan paper
22¾ × 18¾ in. (58 × 47.5 cm)

This study is related in composition to the painting, *Au Café*, ca. 1876–1877, in the in the Kröller-Müller Museum, Otterlo, The Netherlands.

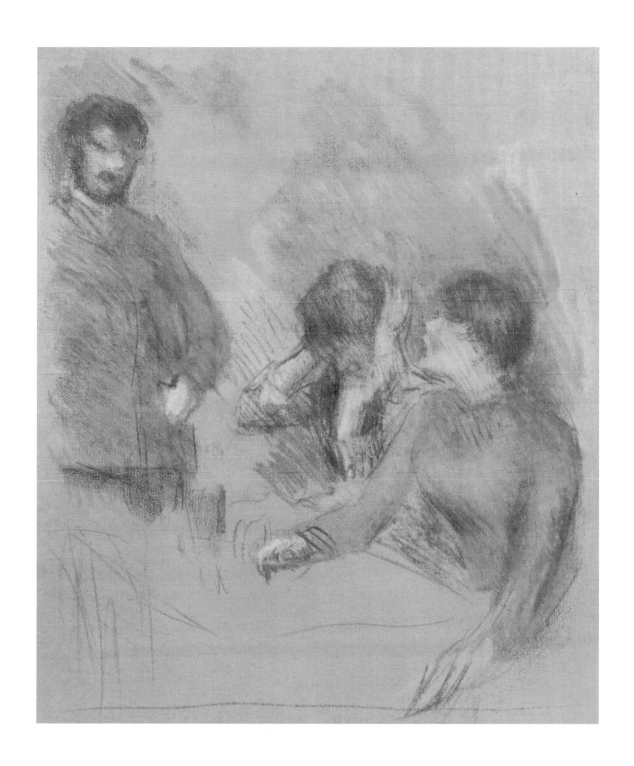

4.

Sur le Boulevard

ca. 1876

Pastel counterproof
on Japan paper
with counterproof monogram
22½ × 18½ in. (57 × 47.2 cm)

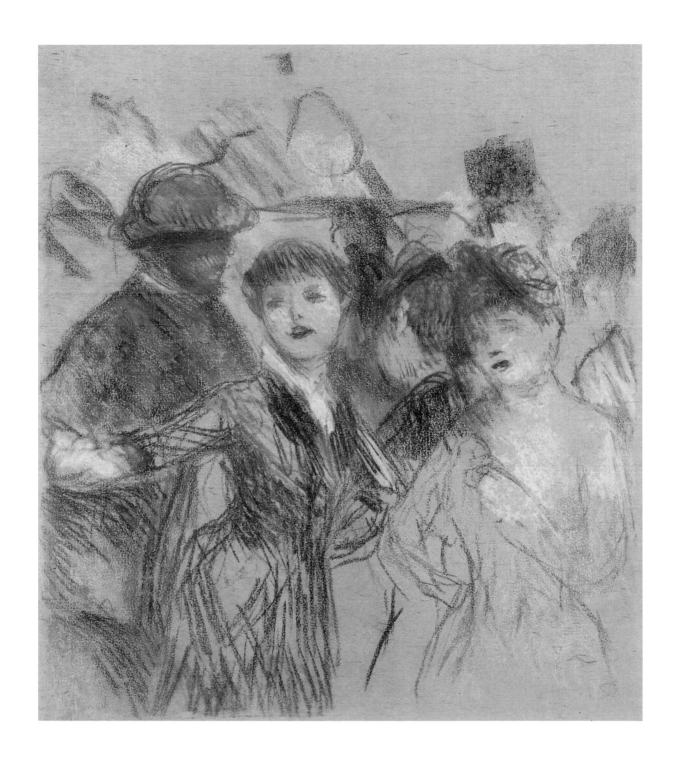

5.

Tête de femme au chapeau

ca. 1884–1885

Pastel counterproof of V. 849
on Japan paper
17¼ × 10¼ in. (43.7 × 26 cm)

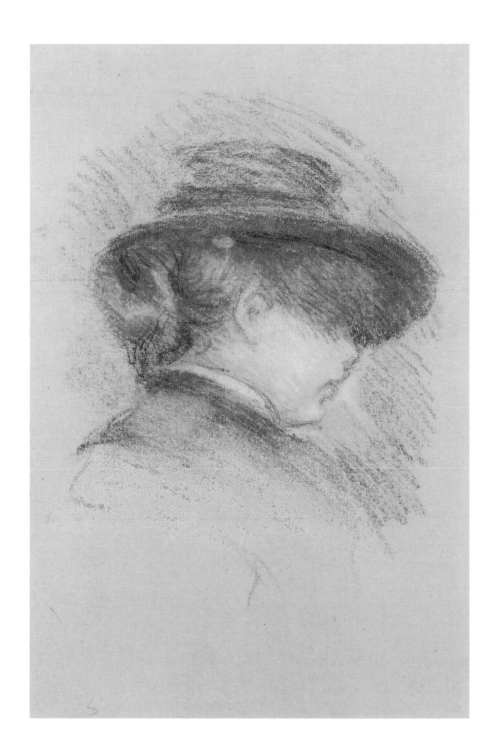

6.

Baigneuse assise

ca. 1885

Pastel counterproof of V. 145
on Japan backed with laid paper
with counterproof signature
ca. 16 × 12 in. (41 × 30.5 cm)

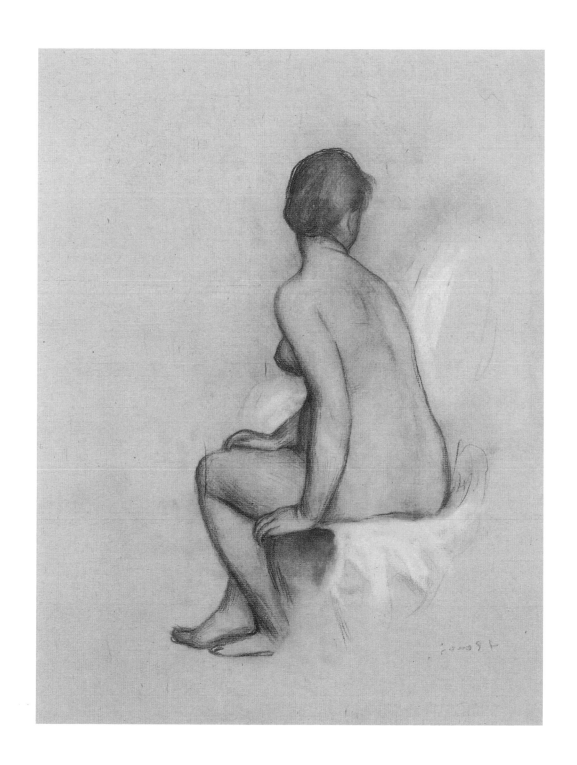

7.

Nu endormi au bras levé

ca. 1885

Pastel counterproof of V. 1339
on Japan paper
with counterproof monogram
$16\frac{7}{8} \times 19\frac{3}{4}$ in. (43×50 cm)

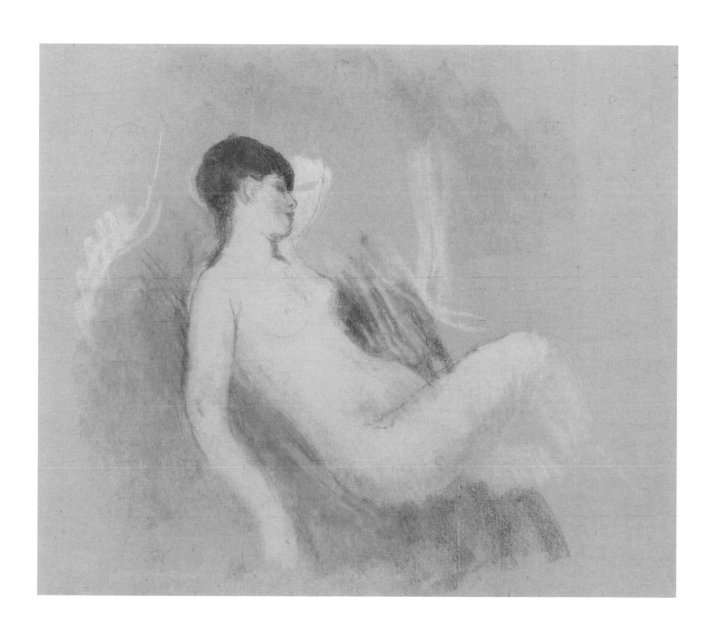

8.

Jeune Fille au cheveux longs

ca. 1885

Pastel counterproof of V. 822
on Japan paper
with counterproof signature
22⅜ × 15¾ in. (57 × 40 cm)

Renoir appears to have referred back to this refined
portrait study for a painting reproduced in Vollard,
vol II, no. 1737 (and in Bernheim-Jeune, *L'Atelier de
Renoir*, Paris, 1931, Vol.II, Pl. 140, no. 435, where it is
titled *Portrait de fillette*, and dated 1912).

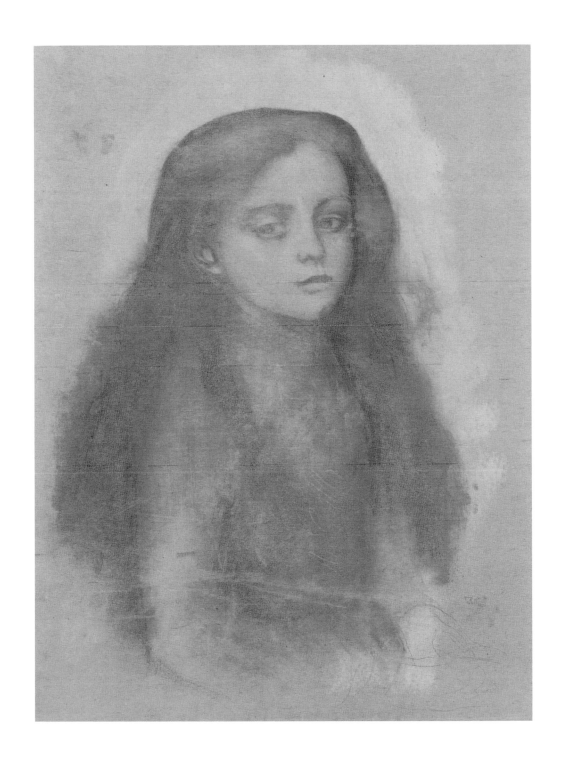

9.

Femme accoudée

ca. 1885–1887

Pastel counterproof
on Japan paper
with counterproof signature
24¾ × 19⅛ in. (62.8 × 48.5 cm)

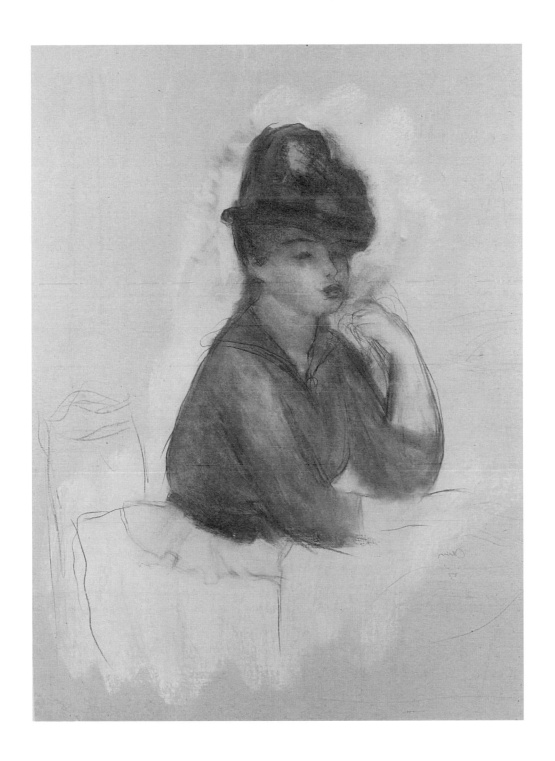

10.

Deux Etudes de jeune fille au chapeau

ca. 1890

Pastel counterproof of V. 1294
on Japan paper
with counterproof monogram
ca. 10¼ × 12 in. (26 × 30.5 cm)

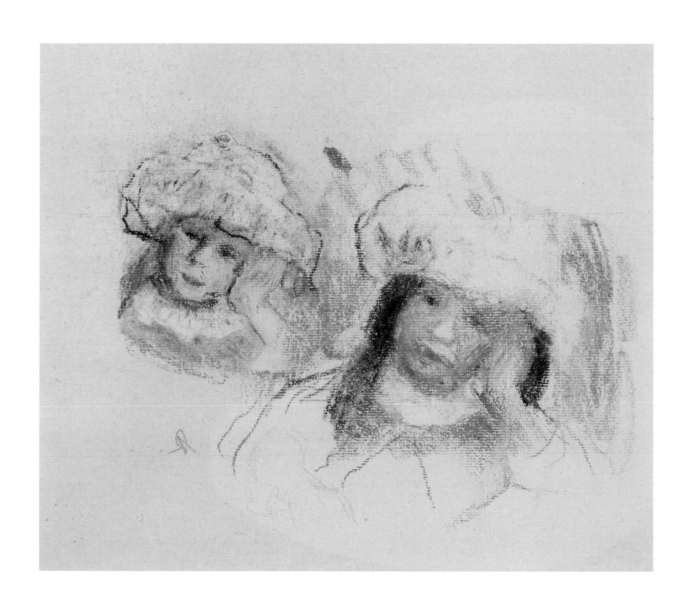

11.

Femme accoudée

ca. 1890–1895

Pastel counterproof
on Japan backed with laid paper
with counterproof monogram
11¾ × 16⅛ in. (29.5 × 40.7 cm)

This subject is closely related to a drawing of the
same title, Vollard, vol. I, no. 515.

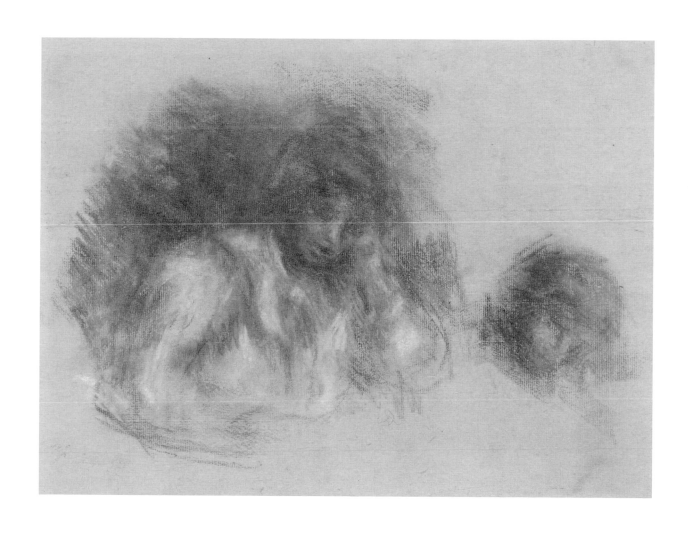

12.

Deux Fillettes allongées dans l'herbe

ca. 1890–1894

Pastel counterproof
on Japan paper
with counterproof signature
14 × 18⅛ in. (35.5 × 46 cm)

This subject is a study for the painting, *Jeunes Filles au bord de la mer*, 1894, 55 × 46 cm, Paris, private collection (reproduced in Gilles Néret, *Renoir, Peintre du Bonheur*, Cologne, Taschen, 2001, P. 281).

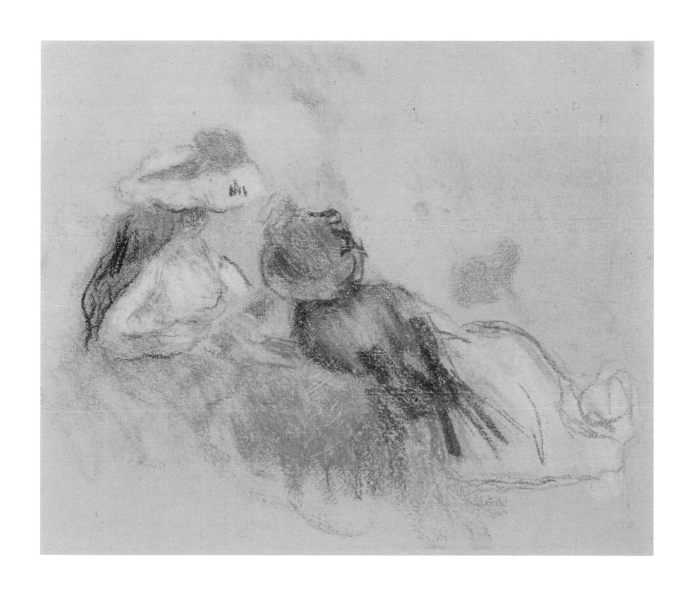

13.

Deux Enfants se donnant la main

ca. 1890–1895

Pastel counterproof
on Japan paper
with counterproof monogram
ca. 36 × 25 in. (ca. 91.5 × 63.5 cm)

The figure of the boy is recalled in Renoir's representation
of his son, Pierre, in the major group portrait, *La Famille
de l'artiste*, 1896, The Barnes Foundation, Merion, PA.

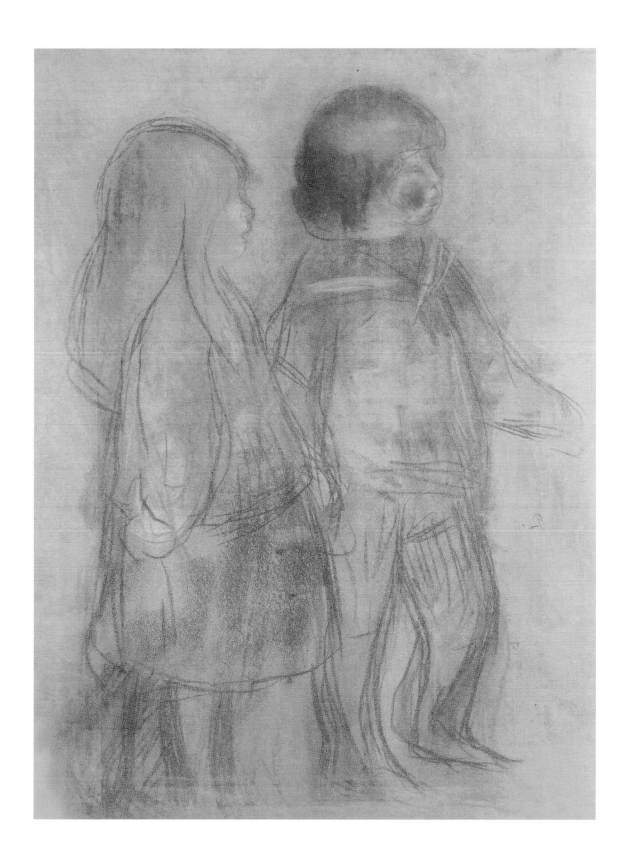

14.

Deux Fillettes dans le jardin de Montmârtre

ca. 1893–1895

Pastel counterproof of V. 1152
on Japan paper
with counterproof signature
23⅜ × 18½ in. (59.5 × 47 cm)

This subject is a study for a painting of the same title, dated 1895 (see Bernheim-Jeune, *L'Atelier de Renoir*, Paris, 1931, Vol. I, Pl. 32, no. 88). The two girls also apear at left in a painting in which the composition has been expanded, *Enfants dans le jardin de Montmârtre* (op. cit. Pl. 26, no. 66).

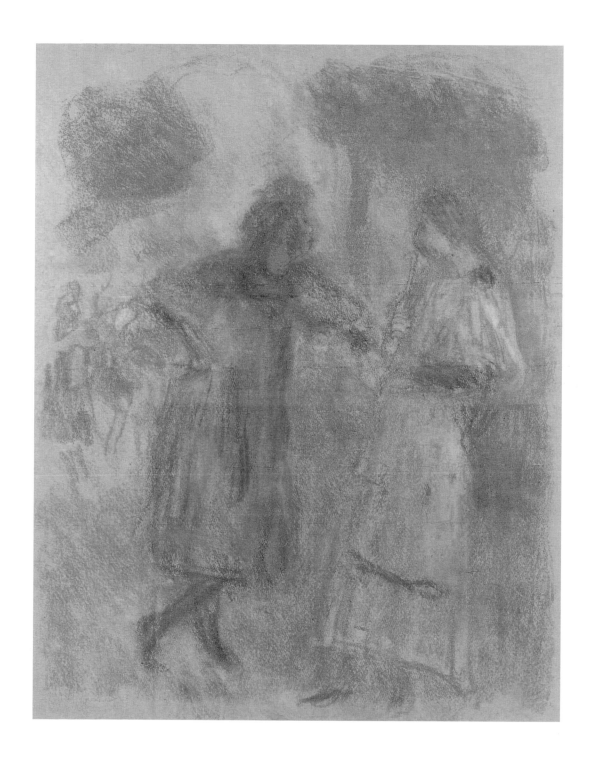

15.

Portrait de femme au chapeau vert

ca. 1890–1893

Pastel counterproof
on Japan paper
22¼ × 17½ in. (56.8 × 44.5 cm)

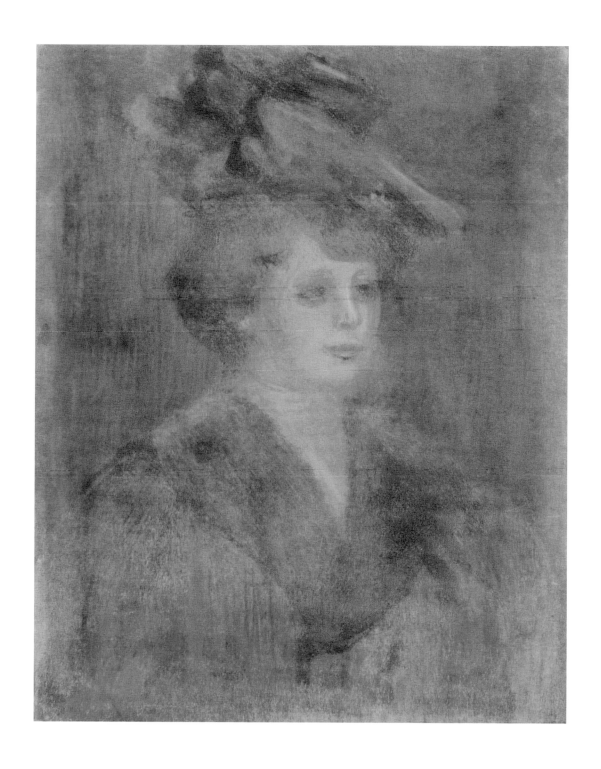

16.

**Trois Etudes de fillette au chapeau,
et esquise de visage**

ca. 1892–1894

Pastel counterproof of V. 913
on Japan paper
19¼ × 12¾ in. (49 × 32.3 cm)

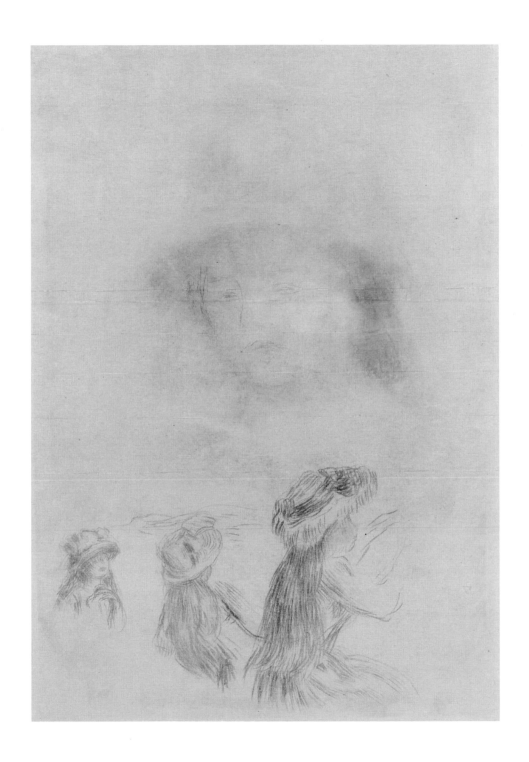

17.

Les Enfants jouant à la balle

ca. 1893

Pastel counterproof of V. 74
on Japan paper
with counterproof signature
23¾ × 18¾ in. (60.5 × 47.5 cm)

This subject is a study for the lithograph of the same
title (Delteil 32, ca. 1900). Renoir executed a black
crayon drawing of the finished design for transfer to
stone (see Foreword, Figs. 1 and 2), but it would surely
have been convenient to have a counterproof of the
pastel, in the same direction as the image appears on
stone, to aid in the process of developing the color ver-
sion of the lithograph.

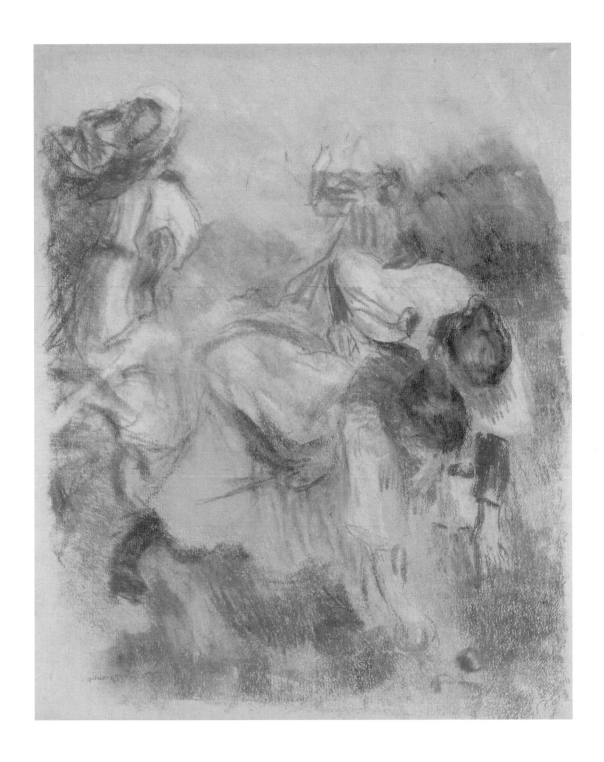

18.

Les Petites Filles au chapeau

ca. 1893

Pastel counterproof of V. 1100
on Japan paper
with counterproof signature
22⅛ × 17 in. (56.4 × 43 cm)

This composition appears to be a study for the lithograph, *Le Chapeau épinglé* (Fig. 4).

It is interesting that the related painting, *Deux jeunes liseuses*, (Los Angeles County Museum of Art, Gift of Dr. and Mrs. Armand Hammer), is in the same direction as the counterproof.

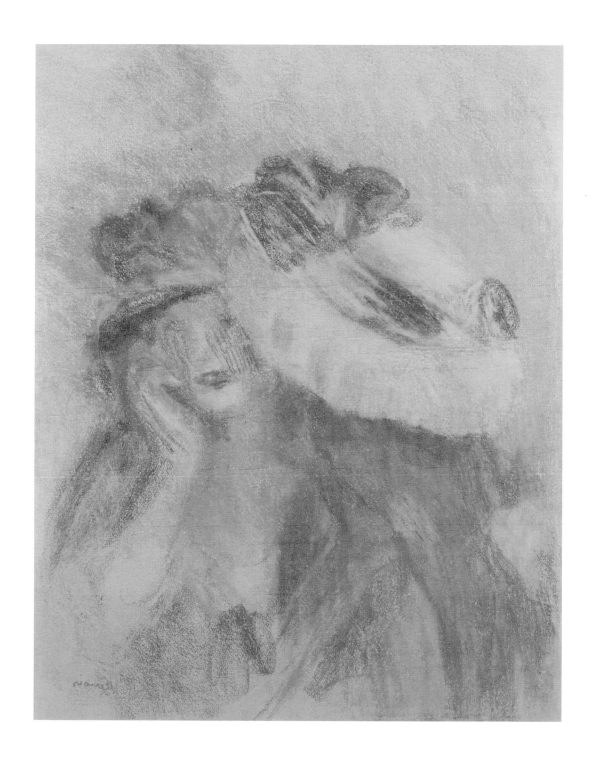

19.

Berthe Morisot et sa fille

ca. 1894

Pastel counterproof of V. 586
on Japan paper
23¾ × 18½ in. (60 × 47 cm)

The pastel, of Berthe Morisot with her daughter,
Julie Manet, is in the Musée du Petit Palais, Paris. (See
François Daulte, *Pierre-Auguste Renoir. Water-colours,
pastels and drawings in colour*, London, Faber & Faber,
1959, no. 17.)

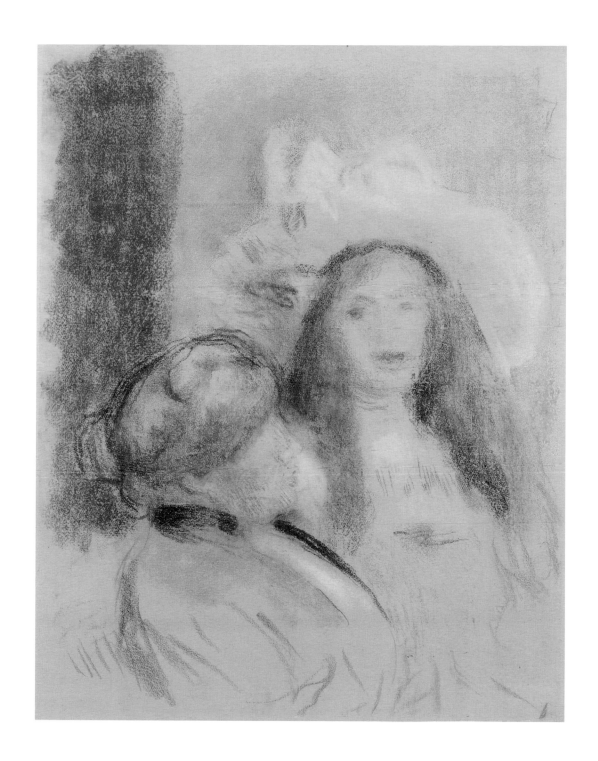

20.

Le Bain

ca. 1894

Pastel counterproof of V. 180
on Japan paper
with counterproof signature
21½ × 18⅝ in. (54.5 × 47 cm)

The pastel from which this counterproof was made,
now in a private collection, was executed in Beaulieu-
sur-Mer. (See François Daulte, Pierre-Auguste Renoir:
Water-colours, pastels and drawings in colour, London,
Faber & Faber, 1959, no. 18.)

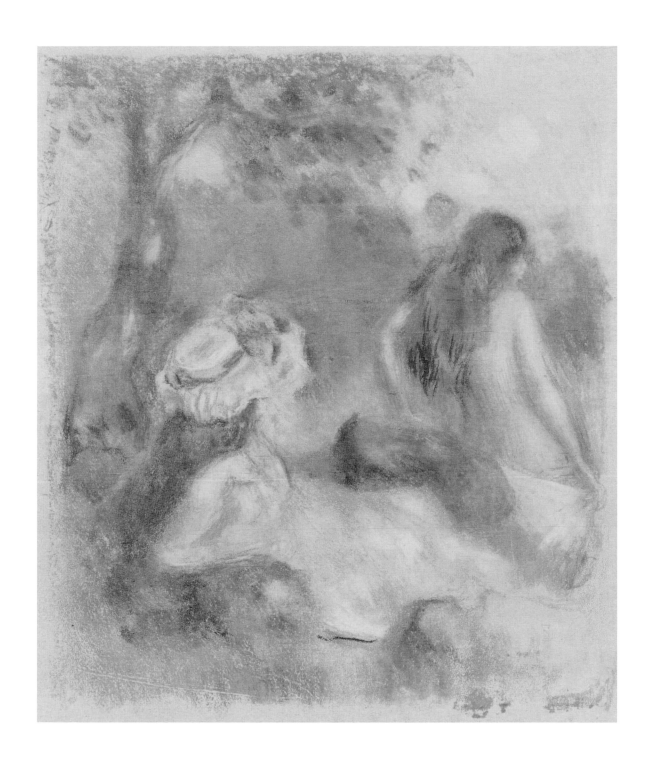

21.

Le Repos

ca. 1895

Pastel counterproof
on Japan backed with laid paper
with counterproof monogram
10⅜ × 13½ in. (26 × 32.5 cm)

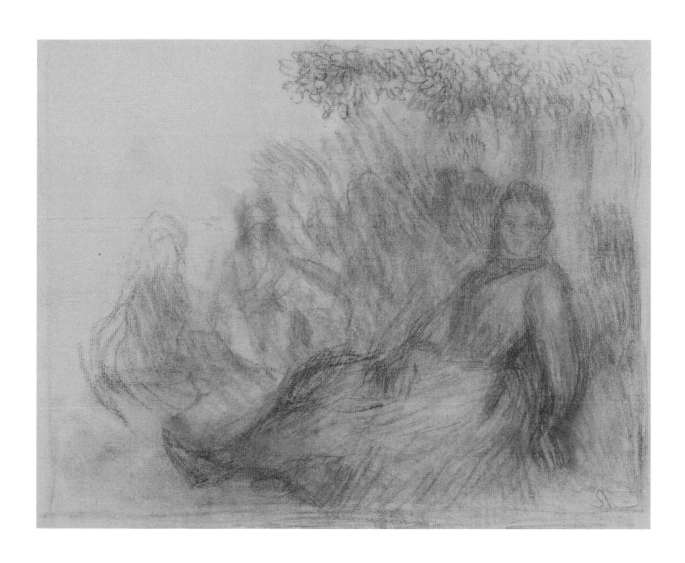

22.

Enfant au Chapeau

ca. 1900

Pastel counterproof of V. 520
on Japan paper
with indistinct counterproof signature
24½ × 18¾ in. (62.5 × 47.7 cm)

The pastel is in the National Museum, Belgrade
(illustrated in Denis Rouart, *The Unknown Degas and
Renoir in the National Museum of Belgrade*, New York,
McGraw-Hill, 1964, p. 43).

 Daulte identifies the model as Jean Renoir, though
this remains a matter of conjecture. (See François
Daulte, Pierre-Auguste Renoir: *Water-colours, pastels
and drawings in colour*, London, Faber & Faber, 1959,
no. 23.)

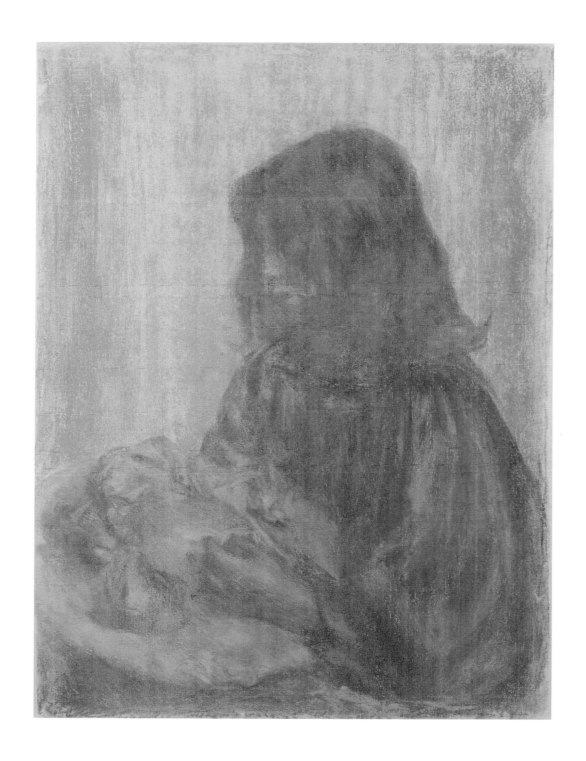

23.

Le Croquet

ca. 1895

Pastel counterproof
on Japan paper
with counterproof signature
23⅜ × 18½ in. (59.3 × 47 cm)

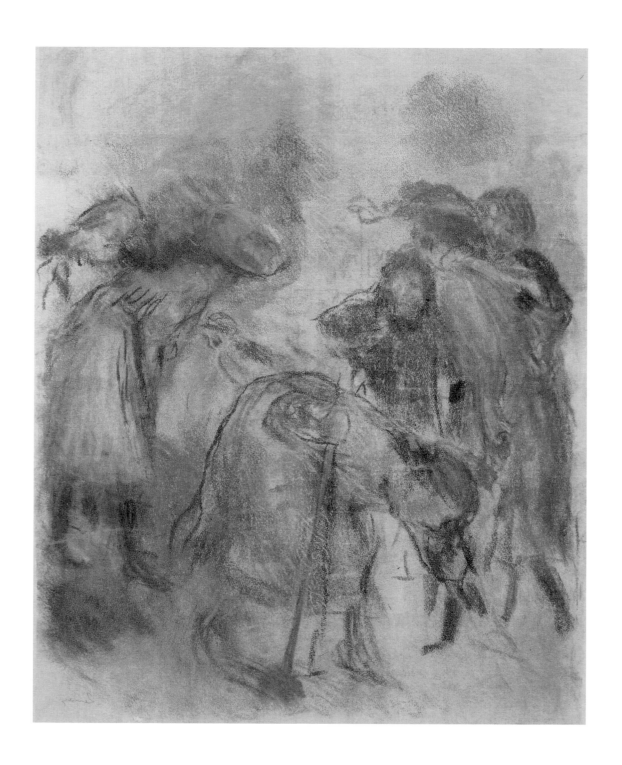

24.

L'Enfant à la chaise (Jean Renoir)

ca. 1895

Pastel counterproof
on Japan paper
23⅛ × 17⅝ in. (59.5 × 44.7 cm)

Closely related to the more cropped composition of
the color lithograph, *L'Enfant au biscuit* (Loys Delteil,
Pierre-Auguste Renoir, L'Oeuvre gravé lithographié, San
Francisco, Alan Wofsy Fine Arts, 1999, no. 31, 1898–1899).

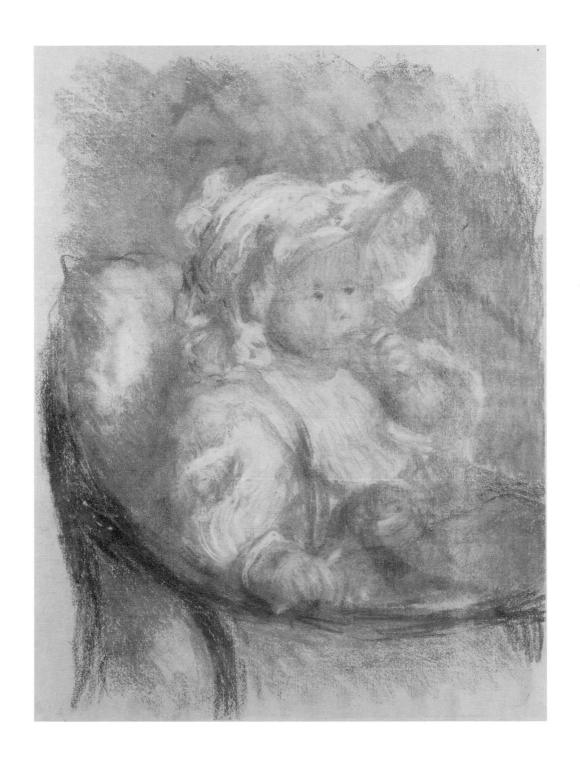

25.

Fillette à l'orange

ca. 1885–1887

Pastel counterproof
on Japan paper
with counterproof signature
20¼ × 14⅛ in. (51.5 × 35.8 cm)

The pastel from which this counterproof was made is
in a private collection (illustrated in François Daulte,
Pierre-Auguste Renoir: *Water-colours, pastels and
drawings in colour*, London, Faber & Faber, 1959, no. 20).

 This work and the two studies of Gabrielle and Jean are
incorporated in a large (56 × 76 cm) pastel composition
(see Bruno F. Schneider, *Renoir*, Berlin, Safari-Verlag,
p. 73); a related painting, *Jean Renoir, Gabrielle et Fillette*,
is reproduced in Bernheim-Jeune, *L'Atelier de Renoir*,
Vol. I, Pl. 23, no. 56.

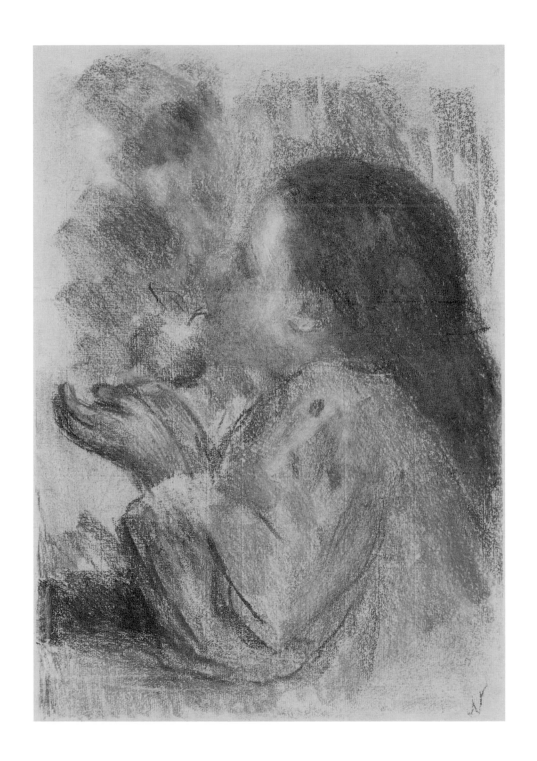

26.

Jean Renoir and Gabrielle

ca. 1895

Pastel counterproof of V. 1217
on Japan paper
with counterproof monogram
19⅜ × 17⅝ in. (48.5 × 45 cm)

The pastel has been retouched by another hand since
the counterproof was taken.

See note to catalogue no. (ex10).

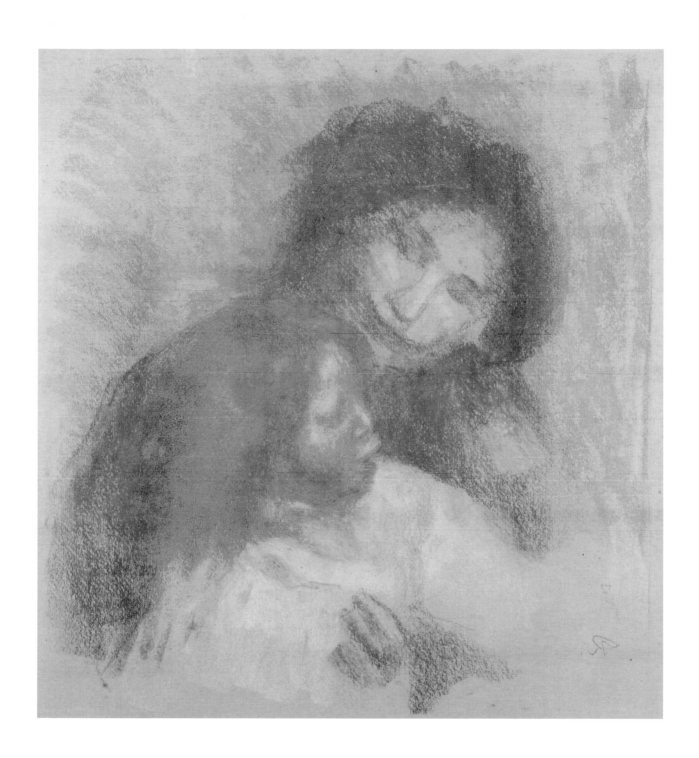

27.

Gabrielle et Jean

ca. 1895

Pastel counterproof of V. 1207
on Japan paper
with counterproof signature
16⅞ × 12⅛ in. (42.5 × 31 cm)

See note to catalogue no. (ex10).

The pastel from which this counterpoof was taken is
also closely related to the painting *Jean Renoir and
Gabrielle* (see Bernheim-Jeune, *L'Atelier de Renoir*,
Paris, 1931, Vol. I, Pl. 55, no. 169, dated 1896).

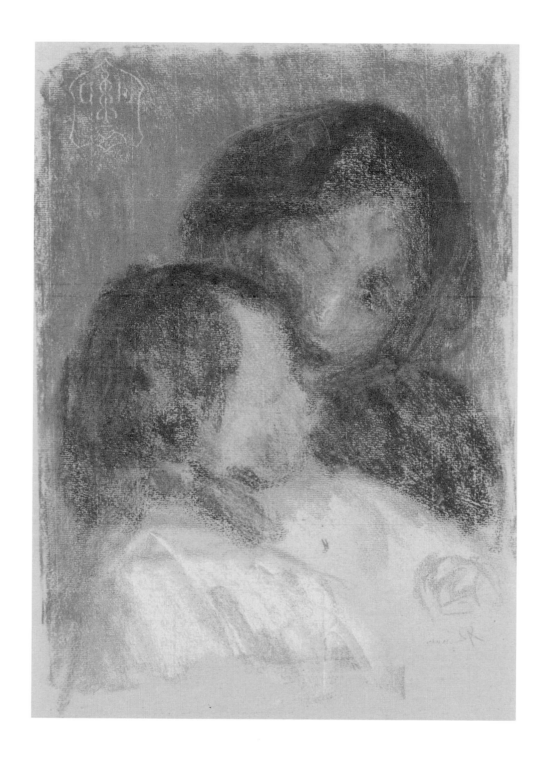

28.

Nu allongé

ca. 1895

Pastel counterproof of V. 831
on Japan paper
with counterproof monogram
13 × 18⅛ in. (33 × 46 cm)

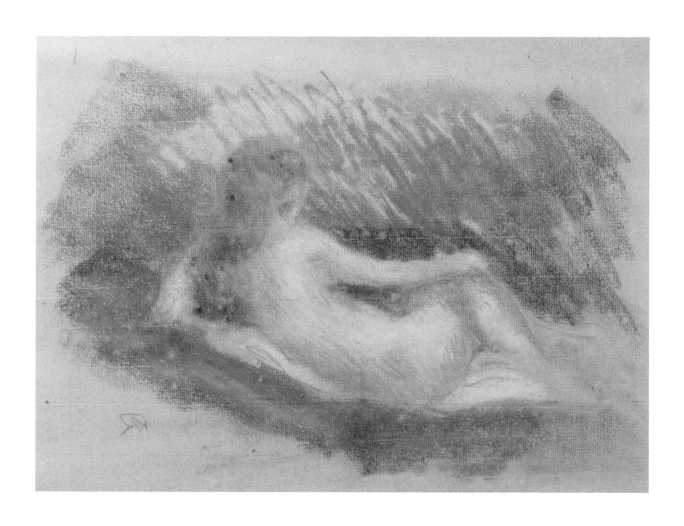

29.

Nu allongé

ca. 1895–1900

Pastel counterproof
on Japan paper
with counterproof monogram
15⅛ × 20⅞ in. (38.5 × 53 cm)

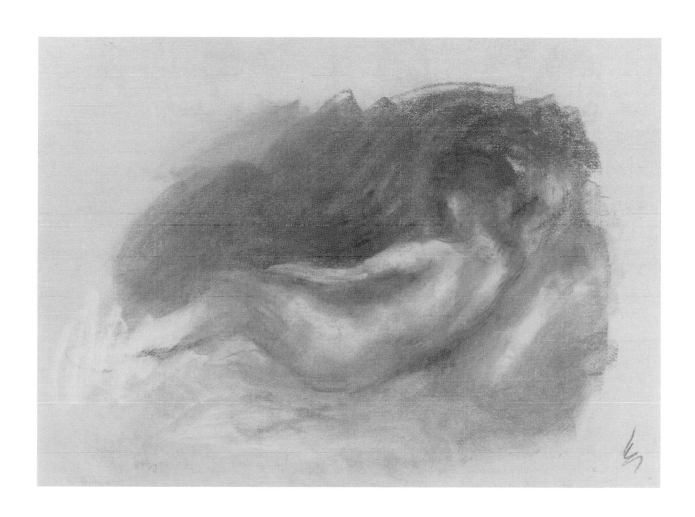

30.

Deux Jeunes Filles lisant, au jardin

ca. 1895–1900

Pastel counterproof of V. 1419
on Japan paper
with counterproof mongram
9½ × 12⅜ in. (24 × 31.5 cm)

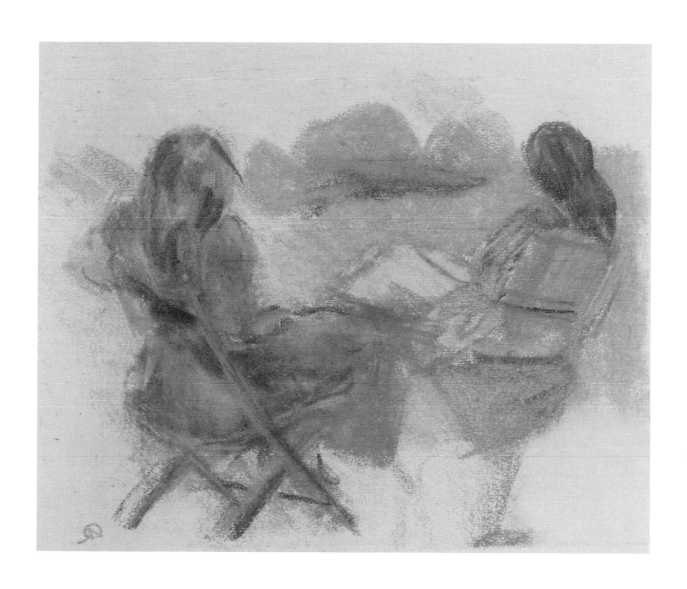

31.

Les Baigneuses au crabe, I

ca. 1897–1900

Pastel counterproof of V. 73 [as *Etude de nus*]
on Japan paper
with counterproof signature
18 × 24 in. (45.5 × 61 cm)

An early sketch for the composition of catalogue
number 32.

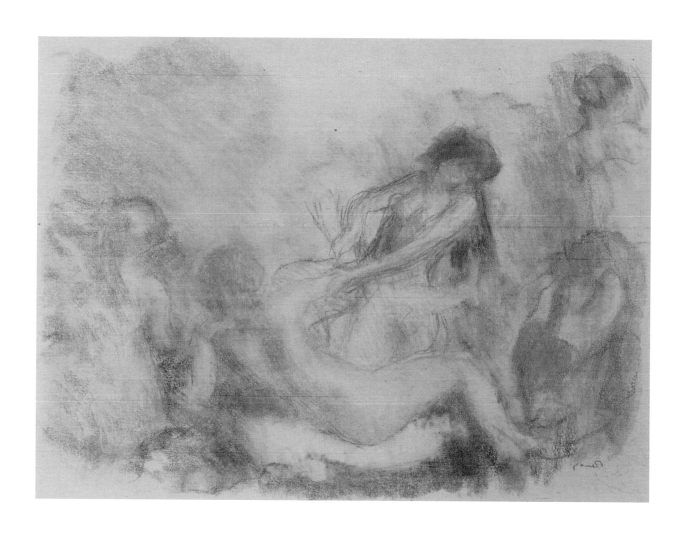

32.

Les Baigneuses au crabe, II

ca. 1897–1900

Pastel counterproof
on Japan paper
18⅛ × 23⅞ in. (45.5 × 60.5 cm)

The pastel from which this counterproof was taken,
formerly in the collection of Mr and Mrs Arthur Murray,
is now the property of Adelson Galleries.

 M. Guy Wildenstein and M. Pascal Perrin have noted
that the artist adjusted the composition by reworking
the contours of the figures after the counterproof was
taken. The composition as a whole is a return by Renoir
to the imagery of his famous painting of 1887, *Les Grandes
Baigneuses*, in the Philadelphia Museum of Art.

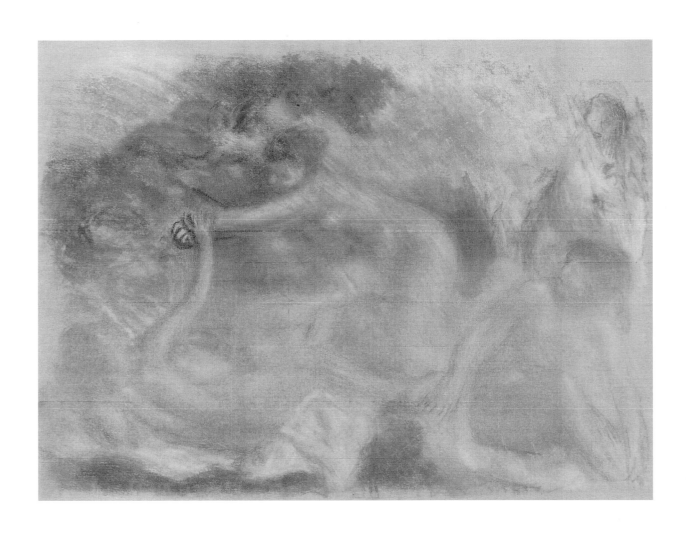

33.

Tête de jeune femme au chapeau
et à la fleur rouge

ca. 1898

Pastel counterproof
on Japan paper
with counterproof signature
22⅜ × 18¼ in. (57 × 46.5 cm)

An almost identical version in oils of this highly finished
portrait is in a private collection. (Exhibition: *Renoir*,
Tokyo, Kyoto, Kasama, July – November, 1993, catalogue
p. 74, no. 22.)

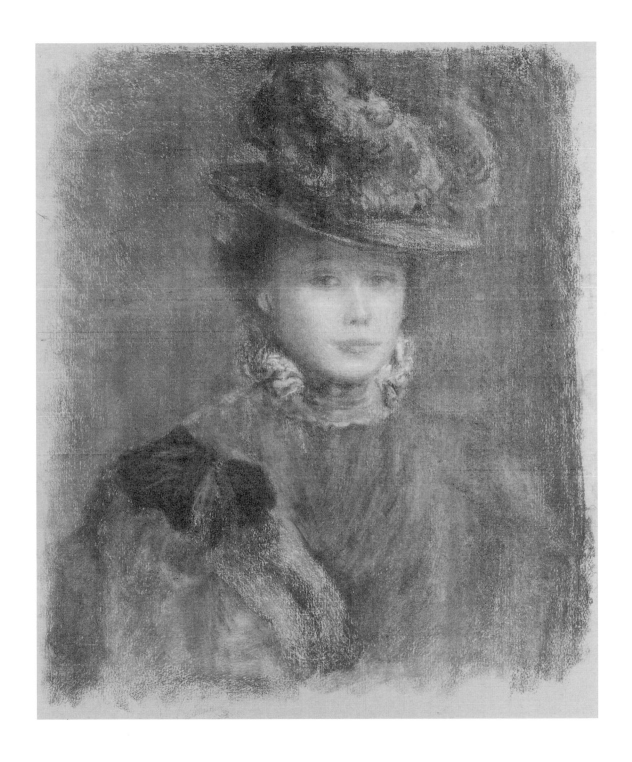

34.

Baigneuse s'essuyant

ca. 1900

Pastel counterproof of V. 1226
on Japan paper
with counterproof monogram
22½ × 18⅜ in. (57.3 × 46.7 cm)

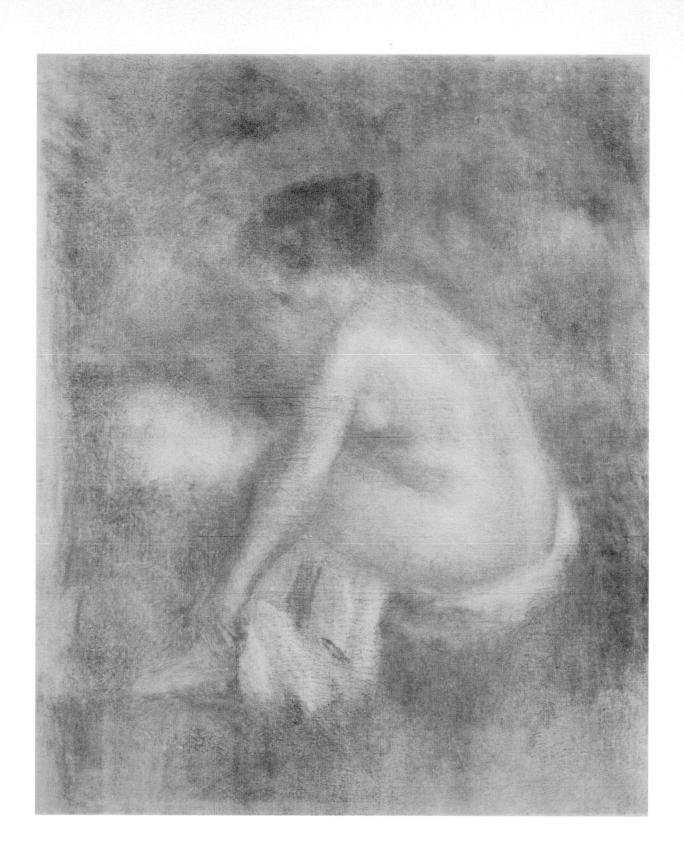

Index to Illustrations

Numbers refer to catalogue numbers

Contributors

Warren Adelson is President of Adelson Galleries and a member of the catalogue raisonné committees for John Singer Sargent and Mary Cassatt. He has contributed to, among other publications, *Childe Hassam, Impressionist; Sargent Abroad: Figures and Landscapes; John Singer Sargent's "El Jaleo"; Sargent's Women*; and *Mary Cassatt, Prints and Drawings from the Artist's Studio.*

Marc Rosen and **Susan Pinsky** are private art dealers and experts in prints and drawings. Mr. Rosen was Senior Vice President at Sotheby's, where he reorganized the Print Department globally and became senior expert in the Department of Impressionist and Modern Paintings, Drawings and Sculpture. Ms. Pinsky, who was trained as an artist, is a former Director of Sotheby's Print Department in New York. Rosen and Pinsky have presented numerous exhibitions at Adelson Galleries, including *Mary Cassatt, Prints and Drawings from the Artist's Studio, Art in a Mirror: The Counterproofs of Mary Cassatt, French Prints of the Late 19th Century* and exhibitions of the works of Gauguin, Pissarro, Redon, Matisse, and Picasso.

Jay E. Cantor, Director of the Mary Cassatt Catalogue Raisonné Committee, has written *Winterthur* and contributed to *Childe Hassam, Impressionist, Mary Cassatt, Prints and Drawings from the Artist's Studio* and *Art in a Mirror: The Counterproofs of Mary Cassatt.* He established the American Paintings Department at Christie's and was founding president of the Georgia O'Keeffe Museum in Santa Fe, New Mexico.